Thank You,
Teacher

TOM BURNS

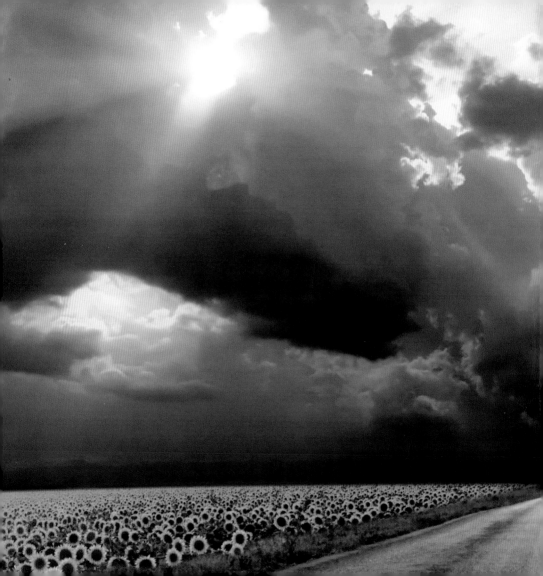

Thank You,

Teacher

An appreciation of a difficult job well done

TOM BURNS

BARRON'S

This edition for the United States, its territories and
dependencies, and Canada published in 2011 by
Barron's Educational Series, Inc.

Conceived and created by
Axis Publishing Limited
8c Accommodation Road
London NW11 8ED
ww.axispublishing.co.uk

Creative Director: Siân Keogh
Art Director: Sean Keogh
Project Editor: Anna Southgate
Production: Bili Books

All inquiries should be addressed to:
Barron's Educational Series, Inc.
250 Wireless Blvd.
Hauppauge, NY 11788
www.barronseduc.com

Library of Congress Control Number: 2010939628

ISBN: 978-0-7641-6419-4

Printed in China
9 8 7 6 5 4 3 2 1

The dream begins with a teacher
who believes in you......

The influence of each
human being on others in this life
is a kind of immortality.

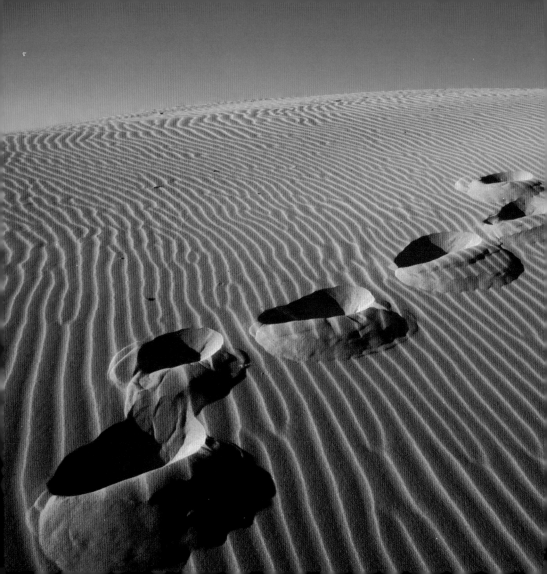

The journey of a
thousand miles

begins with one step.

With a great teacher, life will be a successful journey.

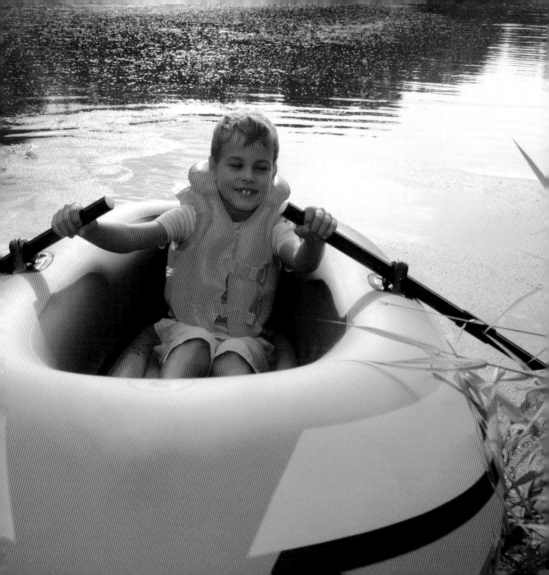

You have awakened

my expectations.

A good teacher gives you something to take
home to think about, besides homework.

You put me to the test and made me do my best.

Teachers excite a boundless sense of curiosity in the young.

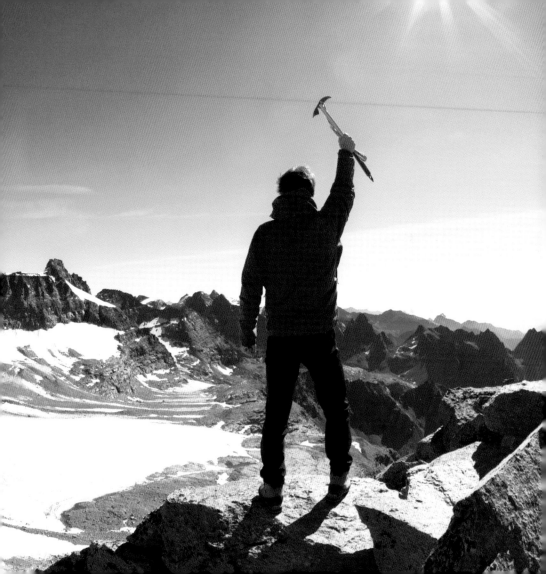

*You have given me
the desire to learn.*

*Your teaching
helped me to see.*

It is better to understand,
than to be understood.

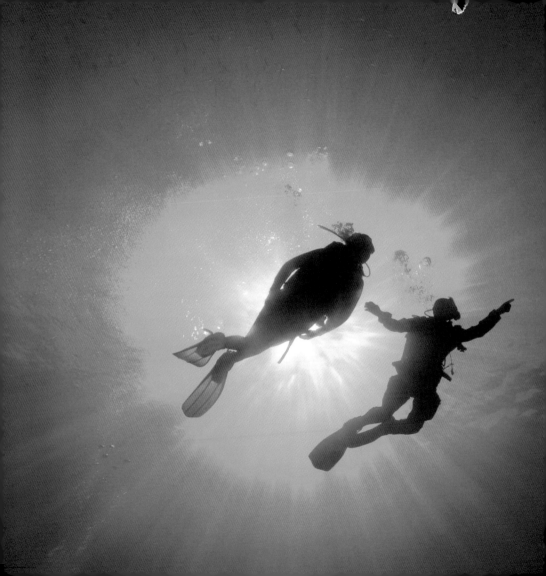

By helping and teaching me I will develop before your eyes.

As a rule, he or she who has the most information will have the greatest success in life.

You have inspired me to aim for the top.

Success, is the reward of toil.

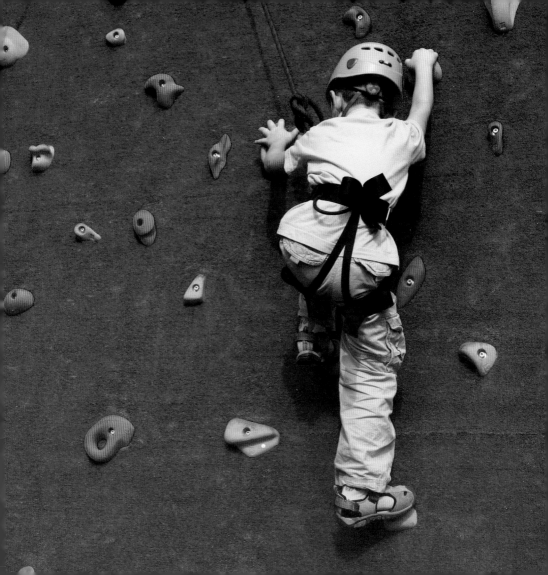

A good teacher is a

good student first.

By repeating his lessons
he aquires excellence.

Teach the children and it will not be necessary to teach the adults.

*You encouraged my efforts
and you made me do my best.*

Success is the sum of small efforts,
repeated day in and day out.

I hear and I forget.

I see and I remember.......

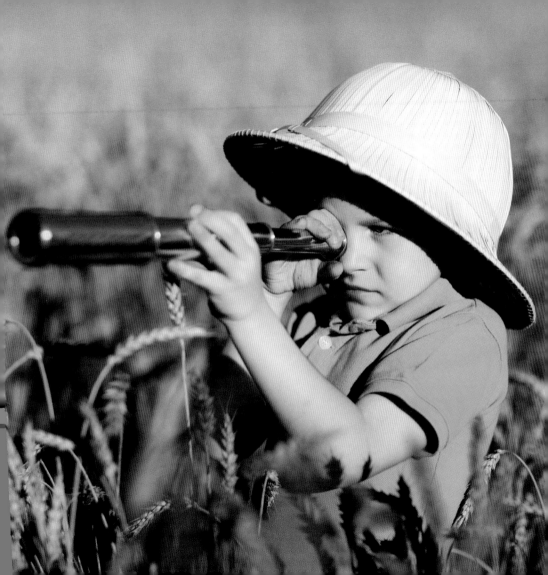

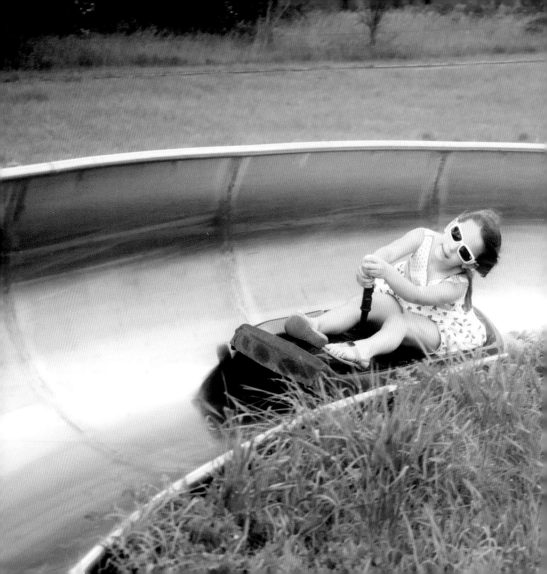

...*I do and I understand.*

Every success is built on the ability to
do better than good enough.

I wasn't always

well behaved...

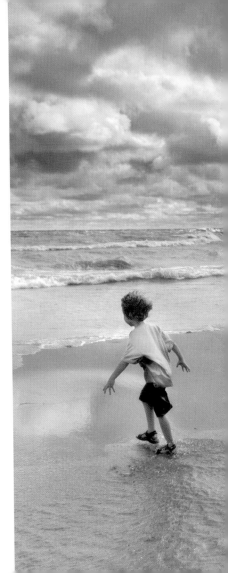

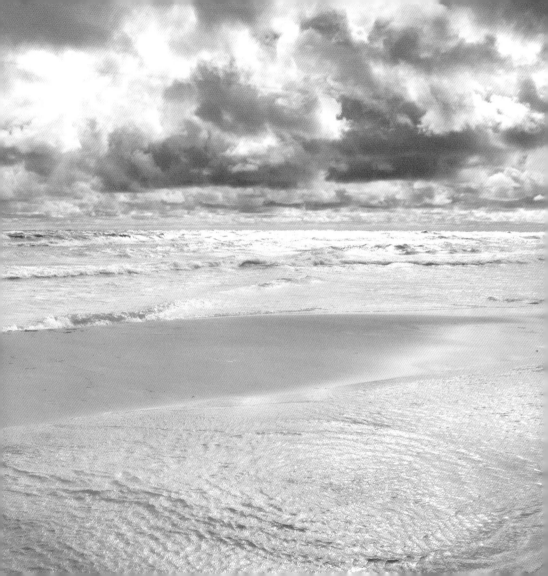

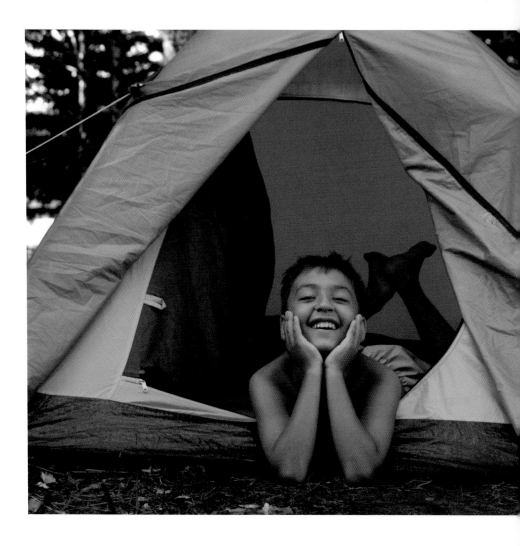

...but I was always well taught.

Some lessons

were a challenge...

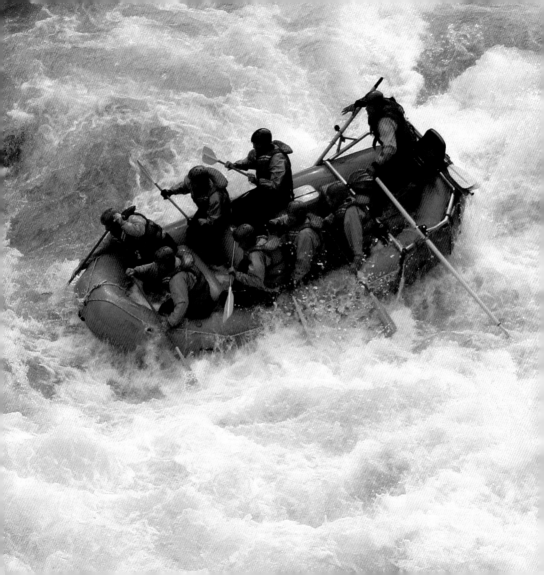

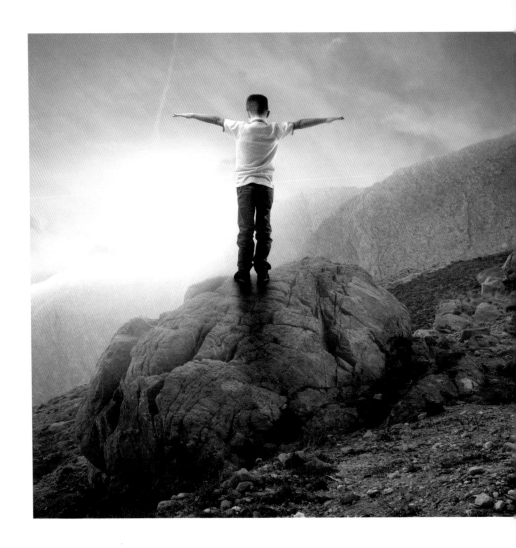

*...and you taught me
how to cope.*

No one is more cherished in this world
than someone who lightens the burden of another.

*Every day you helped
my confidence grow.*

You showed me how to

get the best from school.

Good teaching is about asking the right
questions rather than giving the right answers.

I can soar with the knowledge you have imparted.

Good teachers make learning a pleasure.

You gave me guidance...

The best teacher of children, in brief,
is one who is essentially childlike.

*...and you gave
me friendship.*

A teacher affects eternity; he can
never tell where his influence will stop.

I am ready to face whatever the world may throw my way.

You have given me the knowledge
that I can achieve whatever I wish with
determination and hard work.

You have given me the confidence to grasp every opportunity I get.

Thank you for believing in me, for teaching me with patience and understanding.

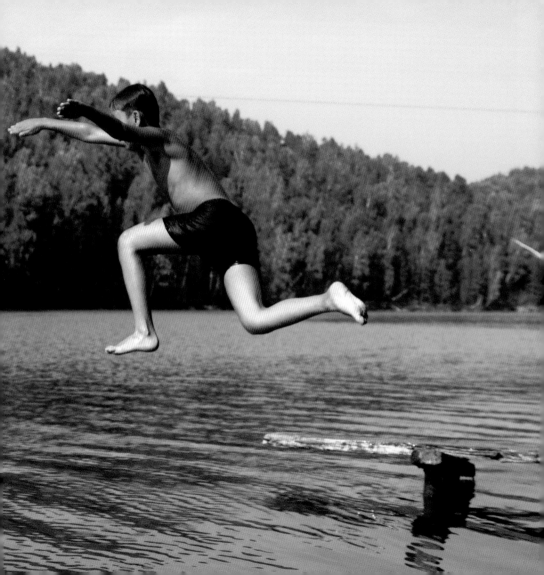

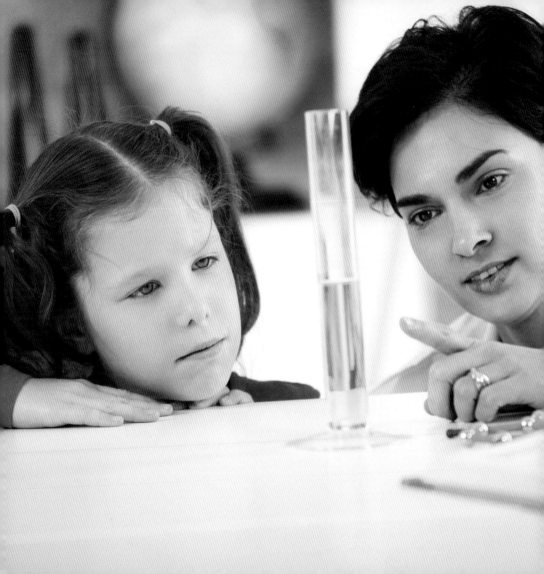

You helped me to realize that learning is the key to a full and happy life.

The art of teaching is the art of assisting discovery.

You always encouraged
me to succeed.

The harder you work the
harder it is to surrender.

Thank you for
guiding me toward
the right path.

What the teacher is, is more
important than what he teaches.

*Life is a journey
and your support has been
a guide throughout.*

A good teacher is a master of
simplification and an enemy of simplism.

Don't be afraid to take
a big step; you cannot cross a
chasm in two small ones.

Natural abilities are like natural
plants; they need pruning by study.

You have made me
what I am today.

My success will be your blessing; I will always be thankful to you.

Gratitude is the heart's memory.

I will always appreciate your kindness.

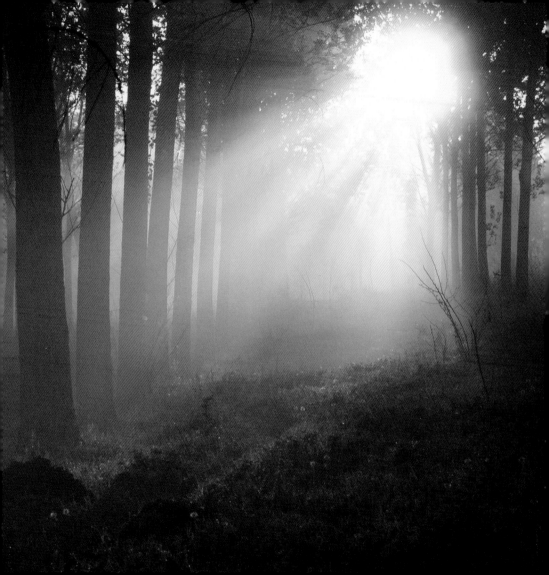

You have been more
than a teacher...

...you are my mentor,
and philosopher.

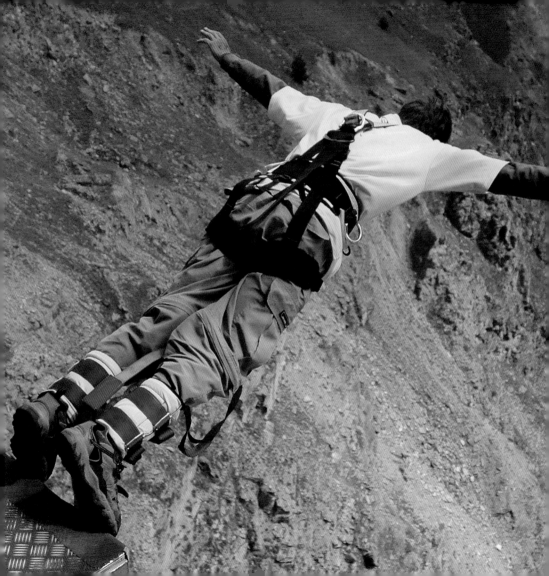

*I will always be grateful
for all the hard work you put
into teaching me.*

The best teachers teach from the heart, not from the book.

T is for talented—
that you surely are...

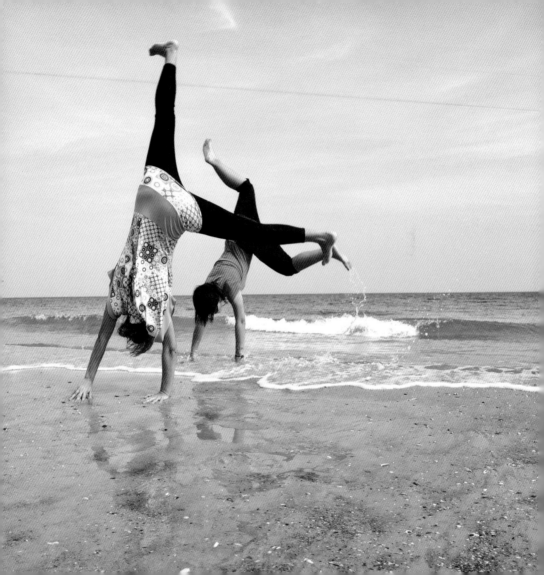

...E is for explaining so patiently...

...A is for the ability to make the class fun...

...C is for correcting

me when I was wrong...

*...H is for helping
me in every way...*

...E is for encouraging

me to do my best...

...R is for rare,
there is only one of you!

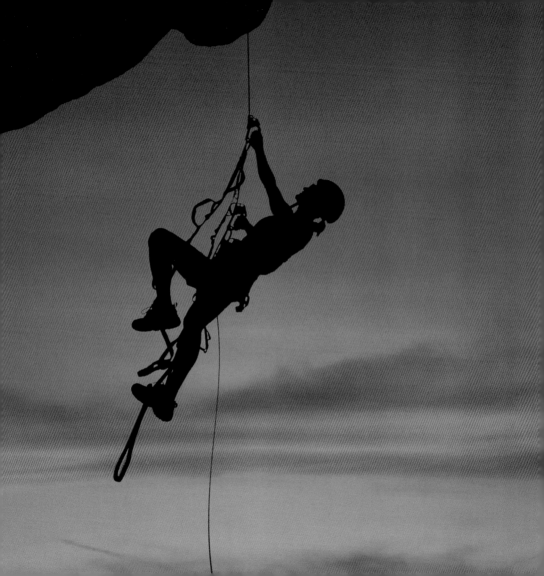

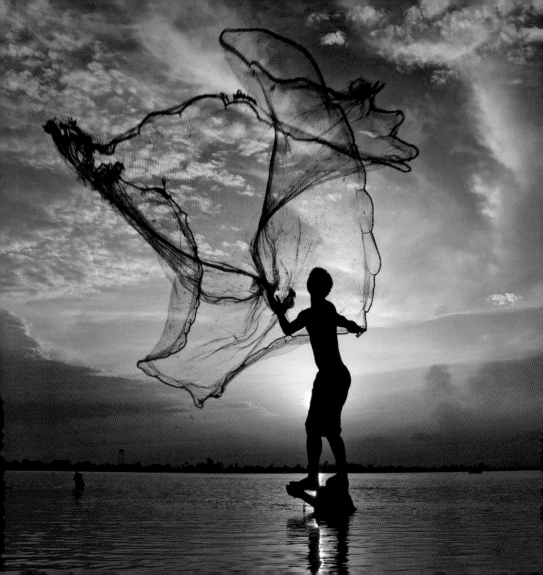

*I'm grateful for your hard
work in helping me to grow...*

...for your constant understanding and for always being there.

Some people come into our lives and quickly go.
Others stay awhile, make footprints on our
hearts and we are never, ever the same.

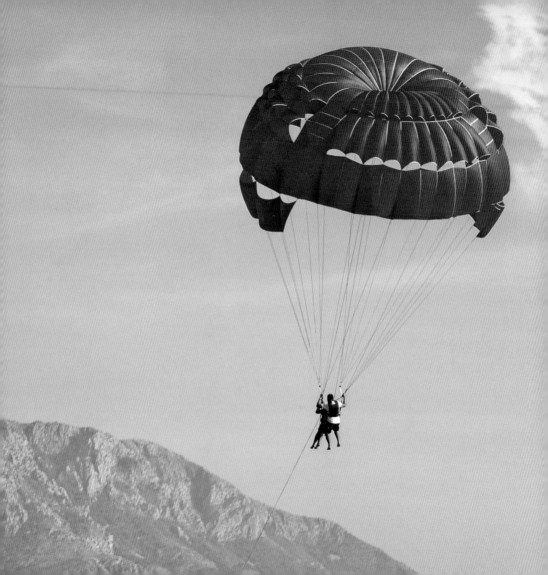

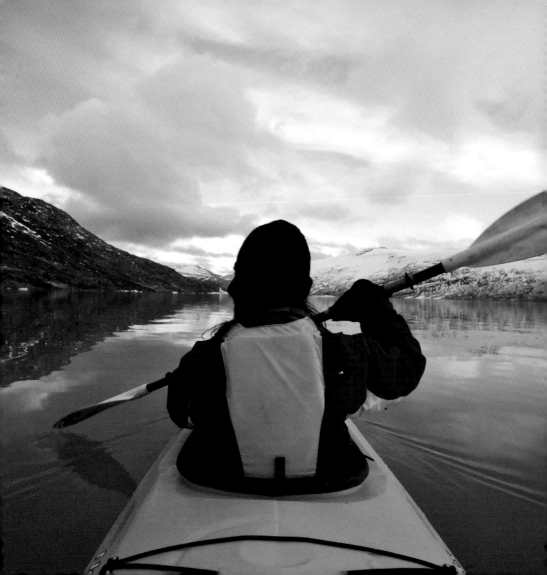

*You helped me
learn to make our world
a better, wiser place.*

Try not to be a man of success but a man of value.

*Every day you
kept me motivated.*

The mediocre teacher tells.
The good teacher explains.
The superior teacher demonstrates.
The great teacher inspires.

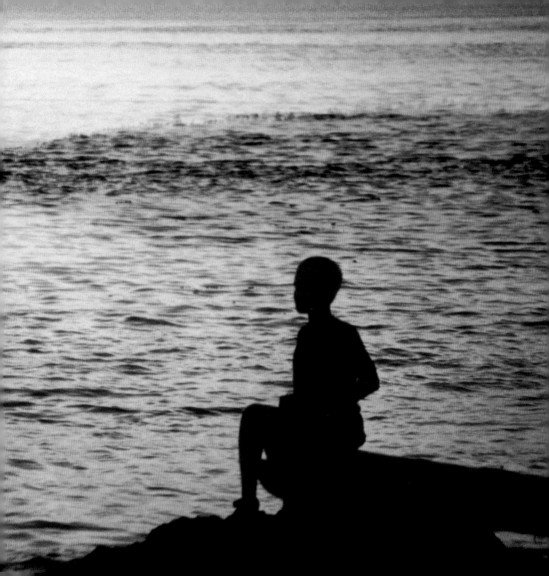

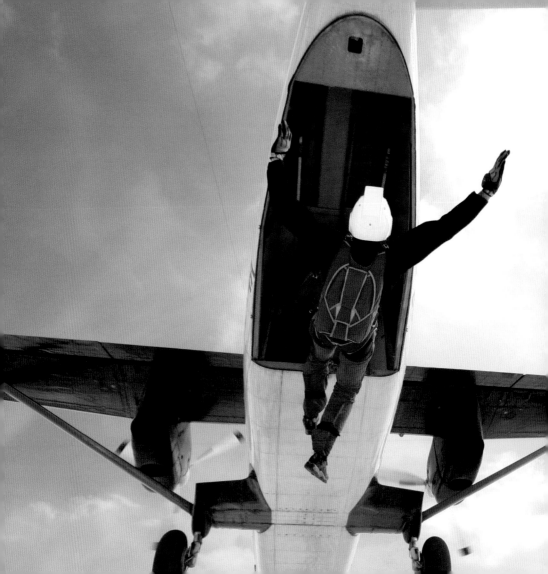

I am thankful for everything you have done to help me fulfill my potential.

A teacher is a compass that activates the
magnets of curiosity, knowledge, and wisdom in a student.

You've helped me strive for goals that can't be bought.

You made me believe I can
make my dreams come true.

You have taught me to
blaze my own trail.

You believed in me and inspired me to enjoy the journey of life.

Things turn out best for those who
make the best of the way things turn out.

You helped me to understand that the most important thing about learning is appetite.

Sometimes it takes darkness for us to find the light.

I will always thank you for the knowledge you have shared.

Your influence will always make me strive to achieve more.

A teacher's purpose is not to create students in his own image, but to develop students who can create their own image.

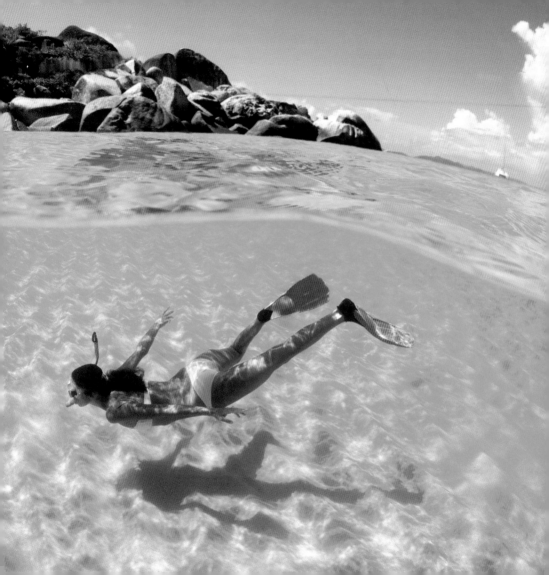

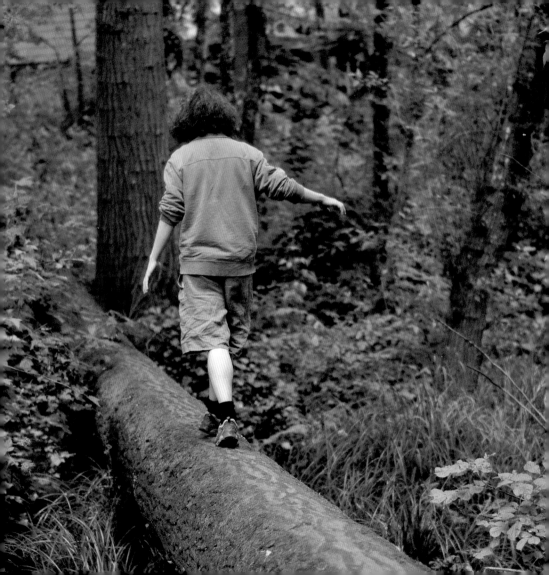

*Thank you not only for
what you did, but for making
me feel I was worth it.*

One looks back with appreciation to the brilliant teachers,
but with gratitude to those who touched our human feelings.

When you teach
you touch the future.

A good teacher is like a candle—it consumes
itself to light the way for others.

Every truth has four corners:
You gave me one corner and it was
up to me to find the other three.

A good teacher awakens your curiosity.

I may not say it always.
But I mean it when I say it.
Thank you for all the
things you have done for me.

I am indebted to my father for living,
but to my teacher for living well.

I would thank you from
the bottom of my heart,
but for you my heart
has no bottom.

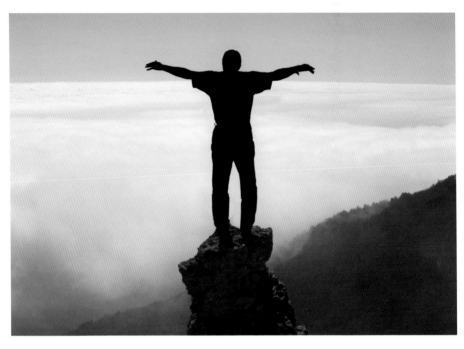

The way you teach,
the knowledge you share, makes you
the World's Best Teacher.